Images of Essence

Photography by Bob Fergeson

Poetry by Shawn Nevins

TAT Foundation Press
Wheeling, WV

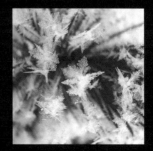

Library of Congress Control Number: 2015932136

ISBN: 978-0-9864457-0-5

Published by TAT Foundation Press

Visit our web site: www.tatfoundation.org

"Nunc fluens facit tempus, nunc stans facit aeternitatem."

The passing now makes time, the standing now makes eternity. – Boethius

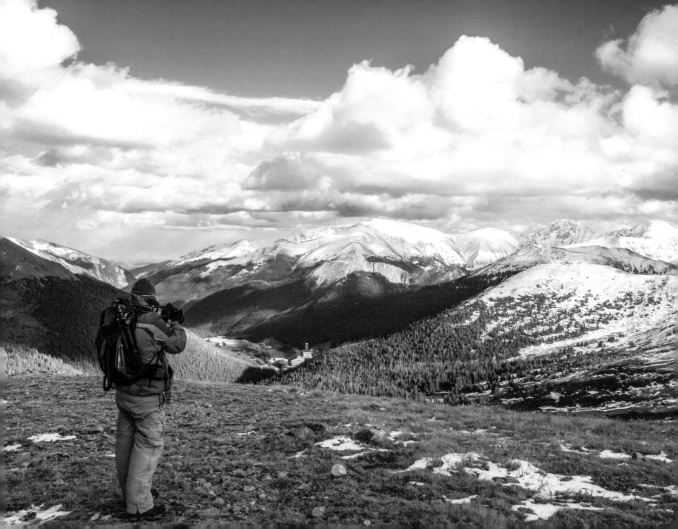

Inside, the grooved curve of a stone, light captured in the eye of a rain drop, path and cloud, pine and mountains of sky – a reunion of captured moments anchoring stark words – a photographer and a poet finding a response to the same inner voice.

What is a lifetime, a day even, but empty space longing to be filled. We are all hunters of eternity, and we peer from the edge of the known, our self, into the seeming void of the not-self. These outer images are symbols of an interior realization we all share. Inside, are visions of the longing for perfection – the borderless, featureless, nameless common ground.

Read slowly and look and listen for your interior reaction to these symbols. Let the stillness without reveal the stillness within.

Though Bob Fergeson lives in the Western United States and Shawn Nevins' work is inspired by the East, their creative wanderings share a common theme: the standing now. It is the moment we all share, when our self-concern is swept away by the wispy hems of clouds, the bone branches of an ancient evergreen, or the cool, impassive face of an alpine lake – when a pause in the passing now of our short lives reveals eternity.

"The Market Opens"

Martins make great cursive sweeps
through the paper of sky
as day's star warms me outside in.
A mantis teaches hungry patience
while the scent of morning's glory
livens the rising eye.
Flowers bend their business towards the sun
like merchants
and customers open wide the pocketbooks
of their lives.
It's good business all around.
God bless our extravagance.

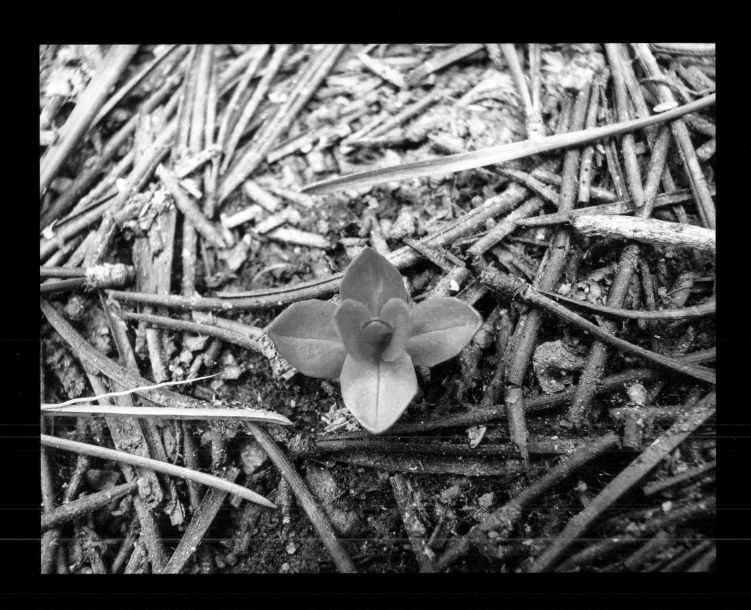

The rouge of morning fills me with wonder
for a droplet of mist.
A young willow is covered in this grace,
dripping with creation,
as a crow's guttural trill
belies his dissatisfaction with my presence.

I'm fog-bound on a stone,
waiting for a gold lance of sunlight
to pierce my side.
Morning:
what a pedestal from which to fall.

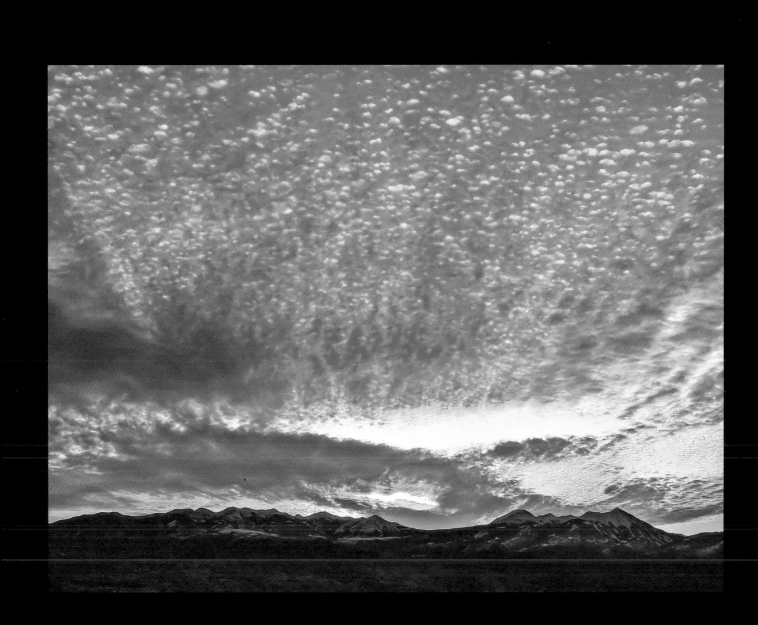

"From Far Across the Green Hills"

From far across the green hills,
Patchworked with misshapen dreams,
Came the vision of my dream
Carried by the wind.
"I shall be," and "We shall be."
Such are the beginnings of our pain.

There is nothing wrong with living,
Except the dying,
And nothing wrong with dreaming,
Except the believing
That all we are is being.

Now, on my hill
Are the stones of the dead
And no wind blows.
The far off hills are quiet and still,
As am I.

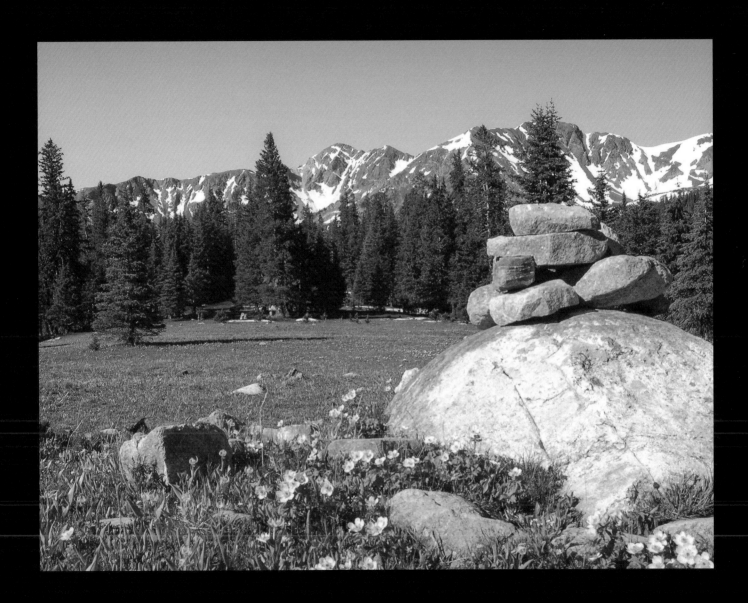

Come deeper with me
to the place of watchers of watching.
To the place where all becomes shadow.
Where our lacy mind blows in a gentle breeze
that is the whispering breath of God.
A god who gently laughs as he himself
slips under waters as still as death.

Leave me and you will find me.
Within and behind is the Golden Find.

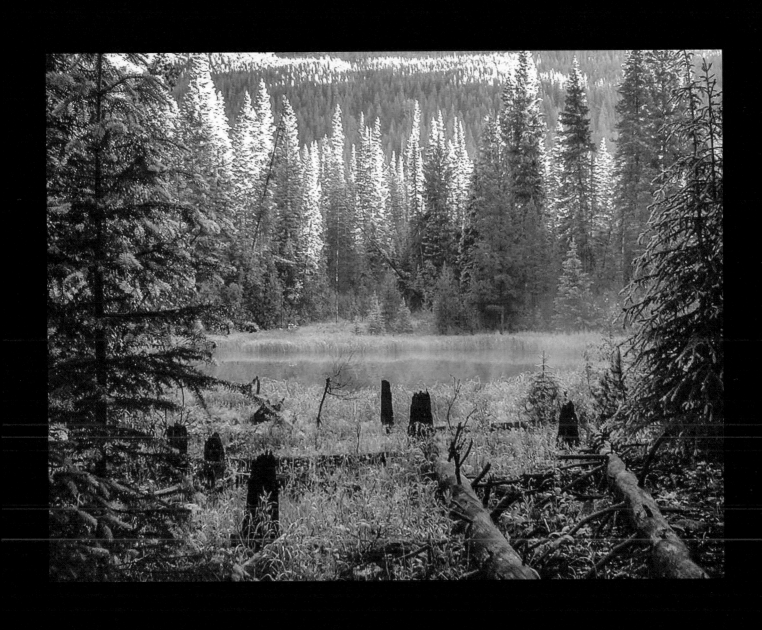

"Lovely"

Without lifting a hand,
the world becomes more
than I could ever make it.

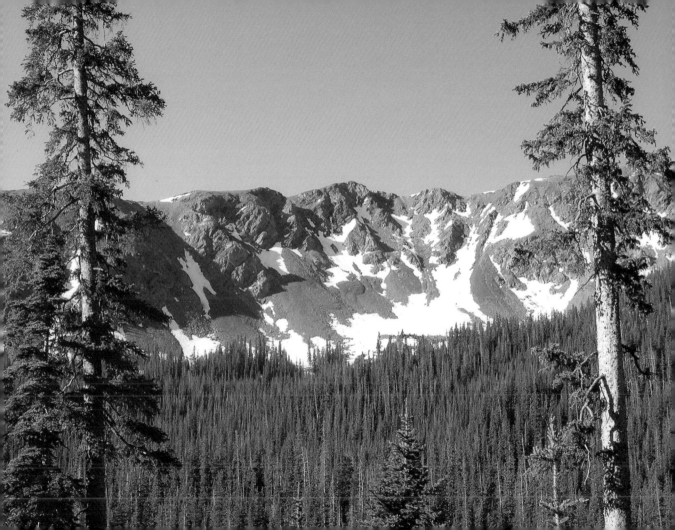

Garden path
ever forward
stop and learn *this* place.

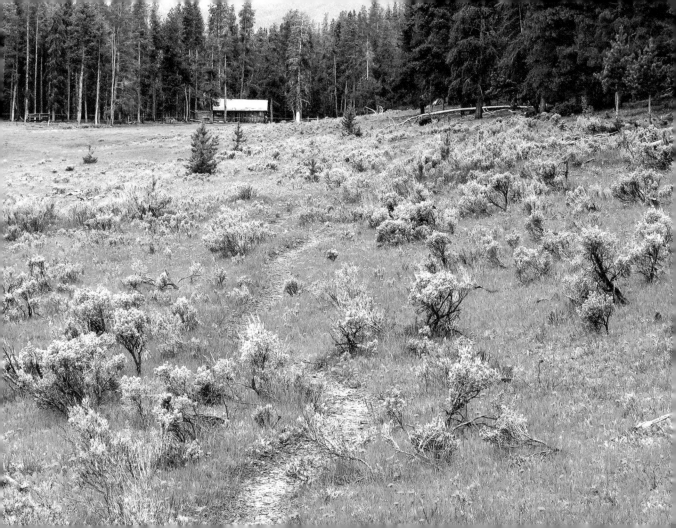

How is each moment
infinitely deep, yet moving;
changing, yet not advancing;
simply becoming anew?

Best to stop there,
at the tipping point inside your self
where death and life, despair and hope,
threaten to pull open the gates of heaven.

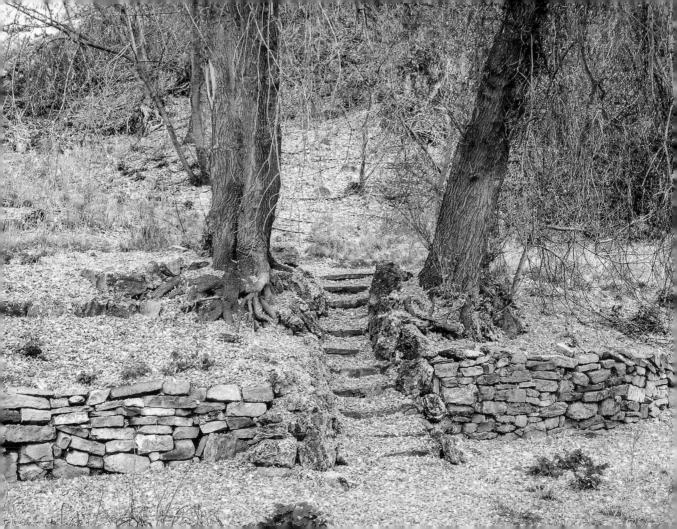

I don't know any more
my place in this vision.
Today I am hopelessly confused
and utterly at rest.
A pale, blue-green sky
is my eye, my heart, my soul, my mind.

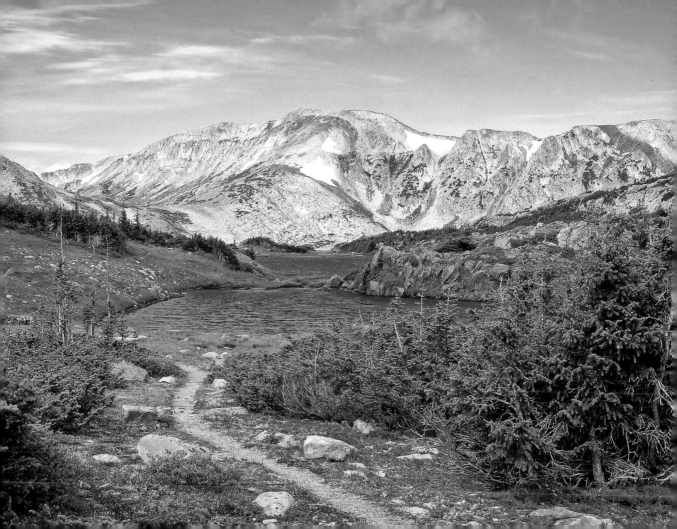

I could say something,
but this room is empty
and I am half-formed,
as if emerging from a wave
or a cloud.
Arranging and rearranging words
to get you to look past my eyes
and into yours.

How can I say it?
In me, in you – This.

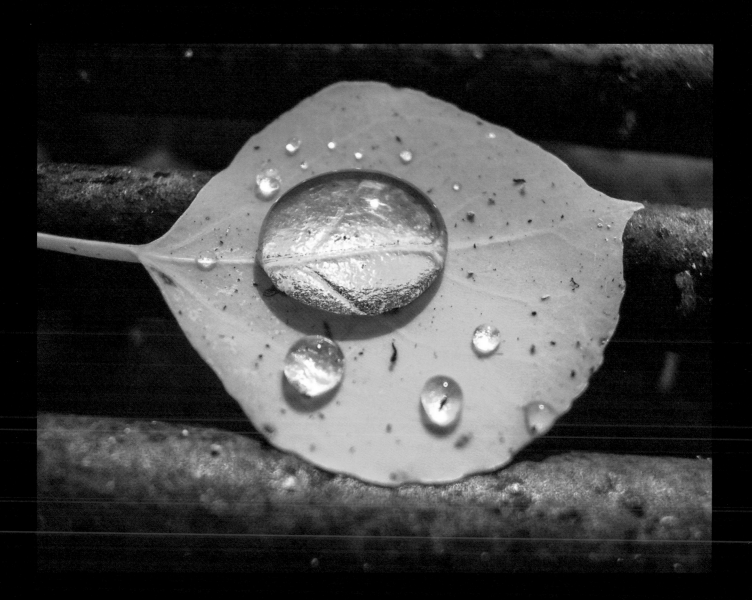

Be sparse.

Let every detail fill your vision.

Turn your self inside out

and save no place for your own.

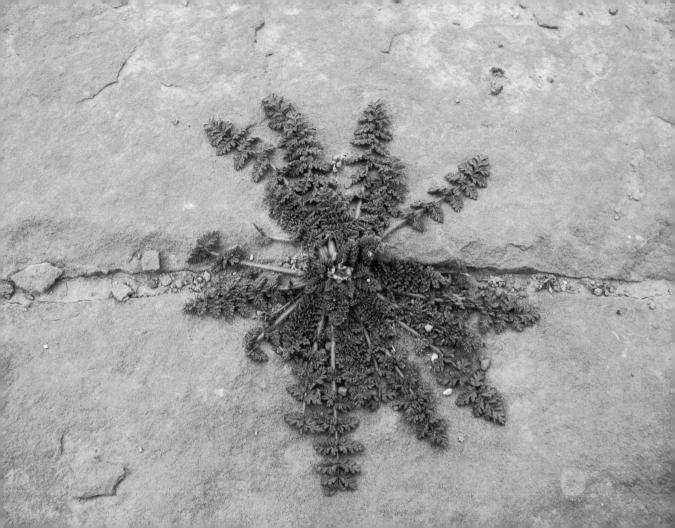

This valley overflows with Silence –
the unceasing undertone of life.
Where does this hand find words
to write of itself?
What was that little man doing?
I've forgotten what meant so much to him.

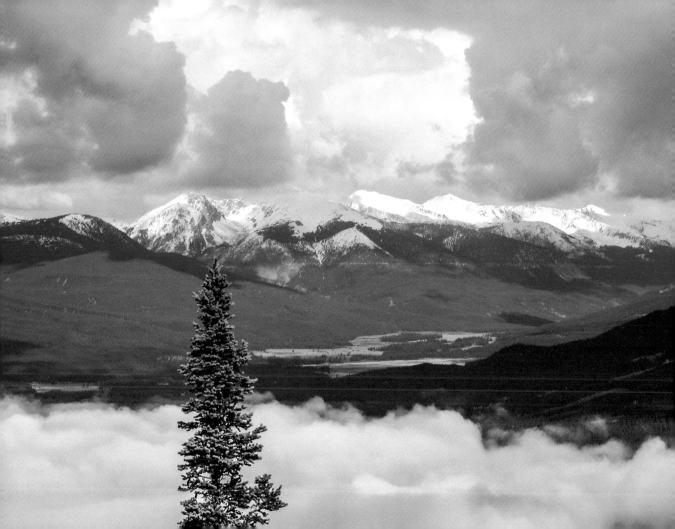

It is a day of fundamentals
when every branch and bird's voice
asks, Who?
Who am I beyond this form?
Who gives me motion, feeling, and voice?

Between the question and the answer
is the real answer.
Because questions and answers are the same talk,
while stunned silence is the edge of awakening.

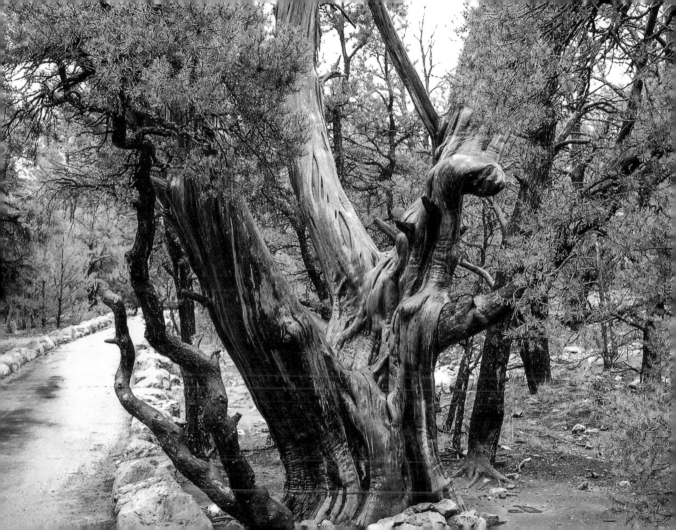

This landscape is empty
like the face of a stranger
to a dying man.
Yet today it lives,
for love is pouring through me
as if I meant to pledge my self
eternally.
I am living in complete ignorance –
a record lined with grooves,
the world giving voice
to my maker,
to love.

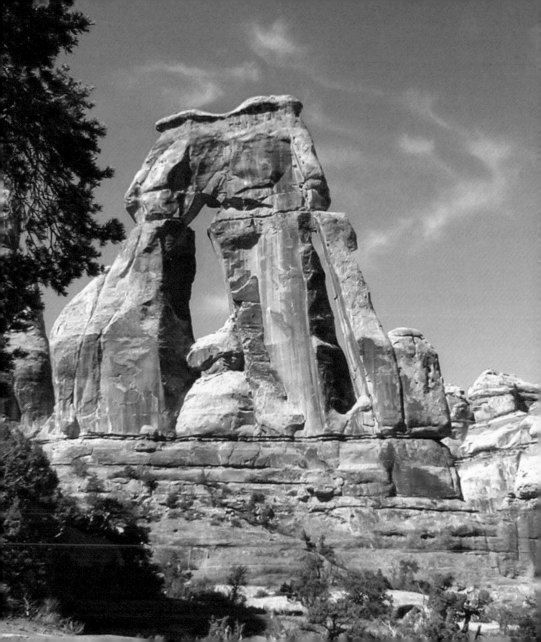

Every motion whispers,
"I live."
I see through every eye:
not one thing, but every thing.
Life scattered like frozen sparkles
on an endless, still ocean.
My heart is ours – vast and empty.
And motion is every eye,
every life seeing itself,
every line a reflection.

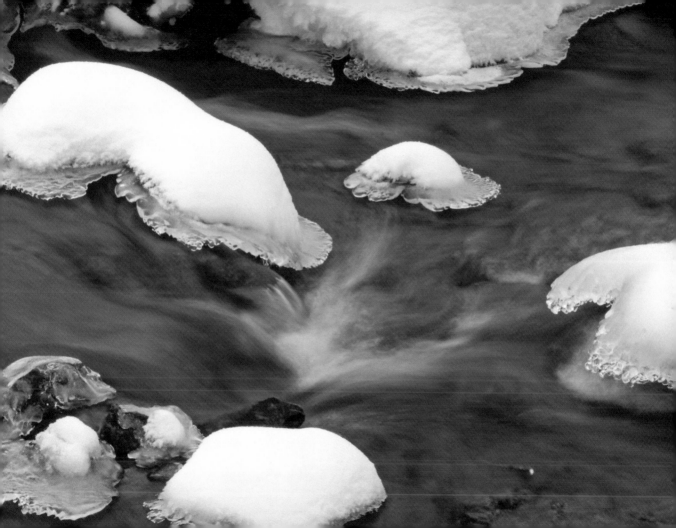

In a moment like this
I would write in blood or carve stone,
write in water or the air,
anywhere
to say what won't stop pouring through me,
absorbing the senses;
calling all attention to the blank slate
upon which the world rests.

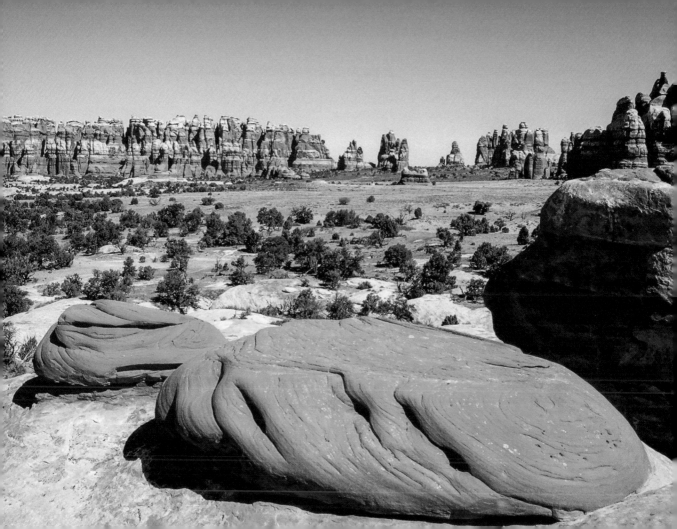

"Homing"

The last words linger in stillness
like lilac and flame
circling round a point of certainty.
"That's it," he said
and a lifetime of longing
rose like white cranes from a hidden marsh
deep within our selves –
a great, uplifting migratory urge
to come home.

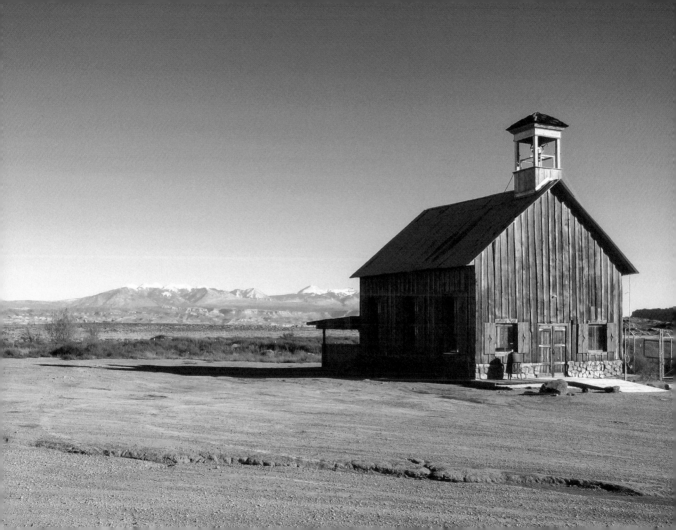

Shadow man,
If you could reach the sky
Rather than living on surfaces,
Blinded by a light obscured
By a lesser part of you,
If you became a sky shadow
Inverting all you believed
Finding an inner light
And, passing through your self,
Spread across the empty universe
Becoming yet remaining what you always were,
Then you would *be*.

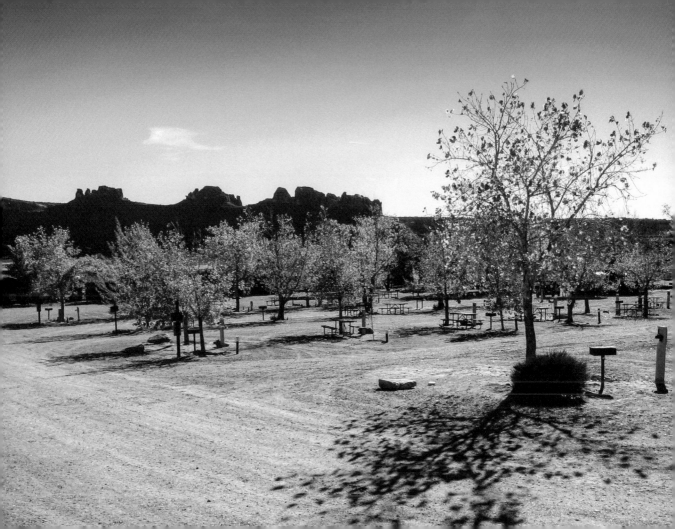

"The Field"

Out beyond the lighted window
waiting for us patiently
is a view of sky eternal –
starry depths quiet and free.

Lose your self in this view of heaven –
not a place for you or me,
but a home, a source unending
of the life which we can be.

Ever-present stillness waiting
calling to us silently.
I am dead and you are dying.
Do not weep, rejoice with me.

The ticking clock has served its purpose.
The quiet round us deepens till,
there is but One who looks upon us,
Who looks upon an empty field.

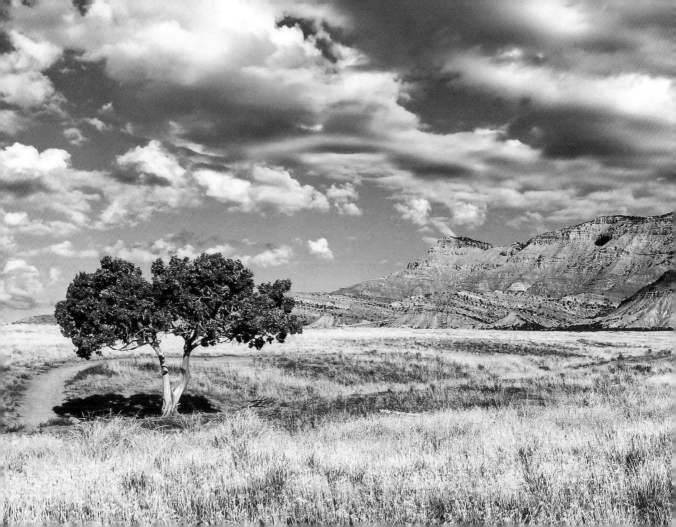

The wind is a translation
speaking of secret longing –
the urge of all things to go home.
Listen,
every edge of every creation
has a story and an ending.

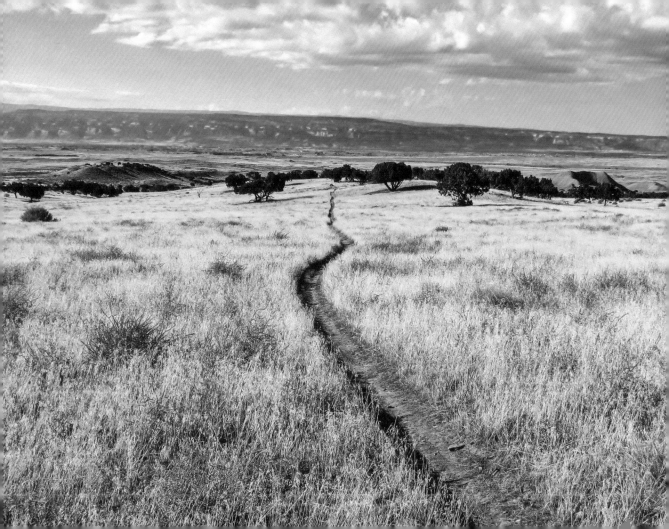

I am the space
between grasses
blown by the wind.
Everything moves through me.

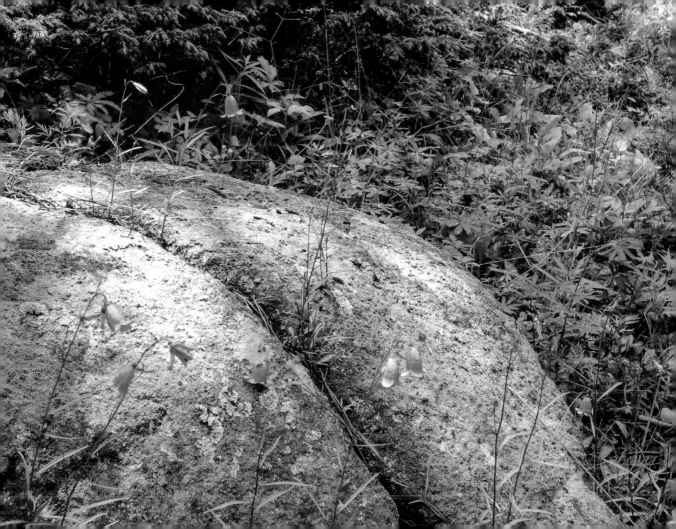

Every word gets wrapped
in this feeling of falling
short of the meaning of being
alone.
Lonely
lingering whispers of words
calling us home,
calling us home.

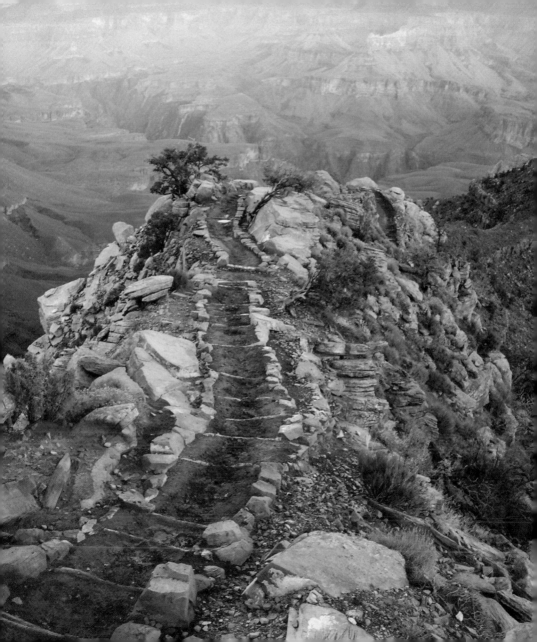

What is this gentle breeze on my face,
but time
seducing me to chase the memory
of this moment.
A stream of moments passes through me.
No longer just touching edges
– deep within and without –
I am anonymous.

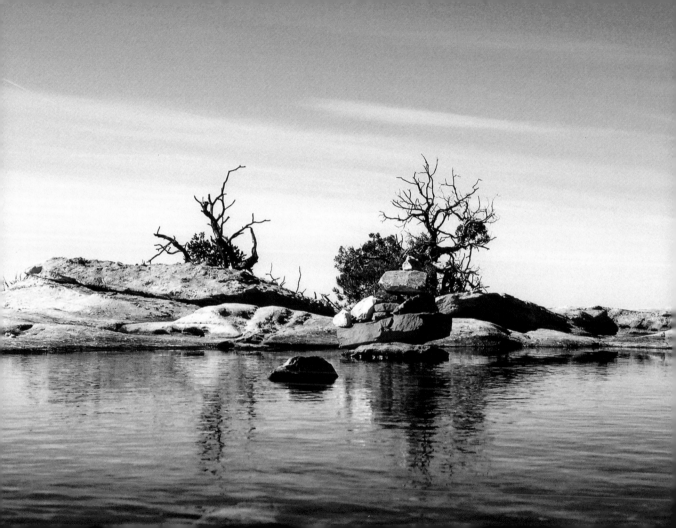

Stop your frantic motion.
There is nothing that must be done.
In stopping, there is nothing to be;
nothing to hold.
Around the corner from action,
is perfect emptiness.
The fields of motion, of time, and of life
are all the same.
Your voice is heard by no one.
No word was ever spoken.
These words – your words – silence....

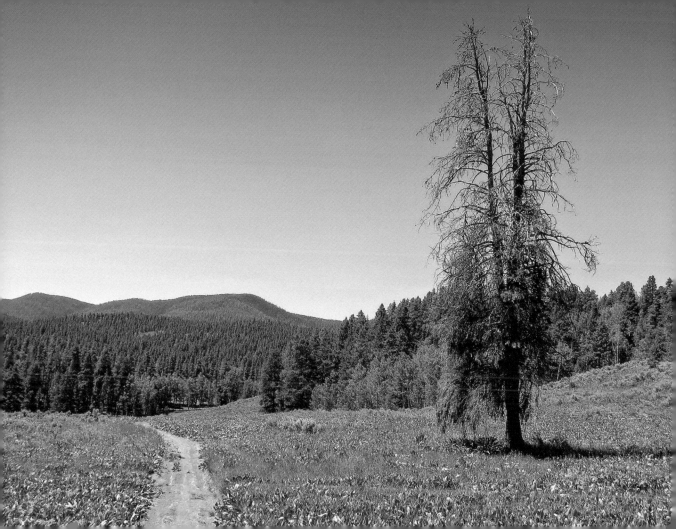

Sounds swirl:
a blackbird bringing food to babies,
a truck lumbering up a low grade,
two dogs in dispute,
the wind through a crevice in my collar.
This is life looping, expanding into space,
then furling back to the beginning.

If it were not for the beginning,
if all were just a pulsing fountain,
no poems would be necessary… but they are.

You make poetry every day,
desperate connections of words:
hellos, goodbyes, pledges of never and forever,
looping, swirling sounds that appear and disappear
with no more hope than dew in the desert.

But you are the dew, you are the desert.
You are these two opposites,
in the same moment,
furled into one.

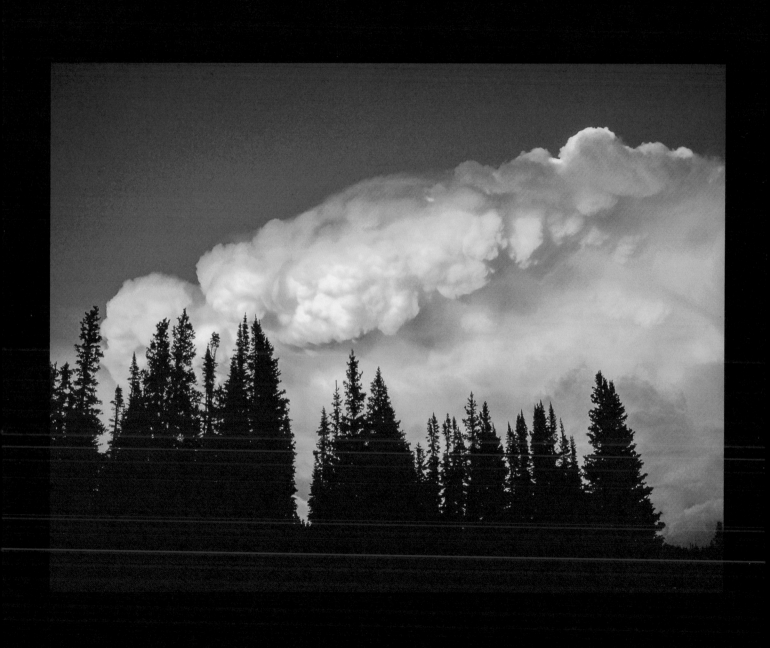

I who has no form,
who has no place –
can you feel me in the wind,
hear me in the waters,
or see me in the trees?

Masks of God unveiling,
speaking in tongues, arguing, seducing.
Where will your faltering form find rest?

Blown by never-ceasing winds,
clouds form and dissolve –
seen as shadows passing over water.

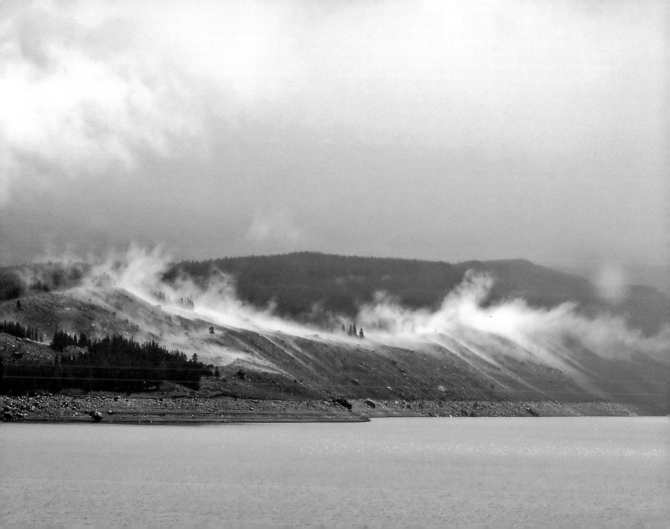

Silence hangs in the air
with bewildering simplicity.
Breathe deeply,
and in the moment after exhalation,
inside and outside reveal no difference.

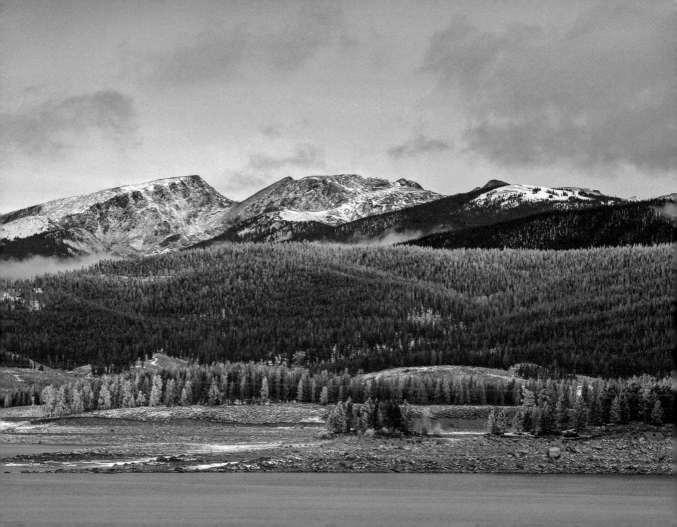

The steady snow
Fills my footprints
Left hours ago.

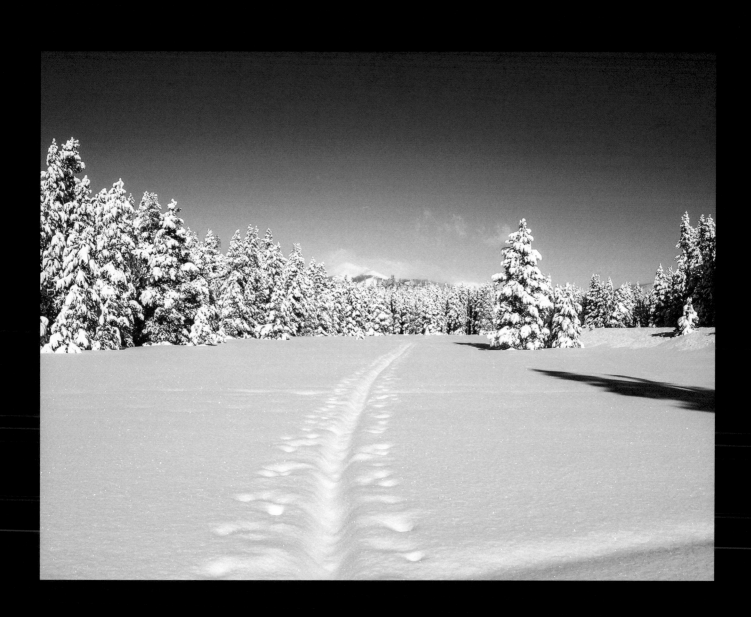

Does God come only in glimpses,
perfection lie only in a delicate balance
of sun and shadow?
Is his voice too weak
to transcend the moment?

Or am I a fool?
Fearfully clasping hands over my senses,
believing I am deaf,
or blind.
Believing I am God,
feeling I am eternal,
believing I am.

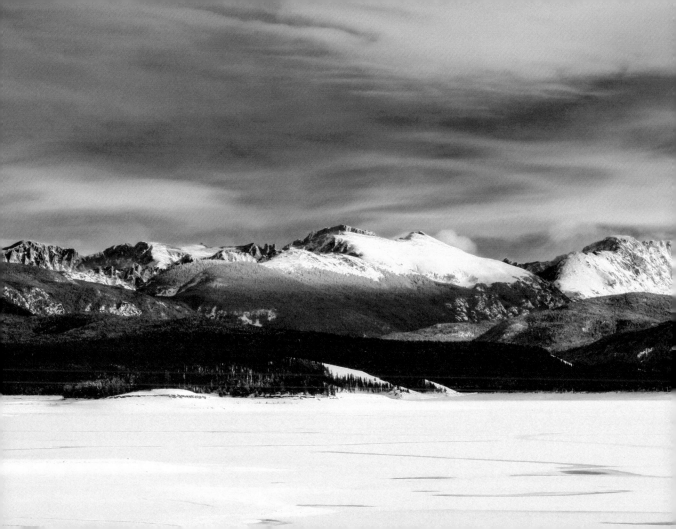

A dark evergreen shouldered with snow,
its farthest needles frozen in glassy ice.
All is still and quiet,
yet there is dancing
beneath these frozen chandeliers,
a whispering wind that makes light
sing and shimmer
within this quiet forest,
within this quiet world.
How are you both wind and light,
and the black and icy night?

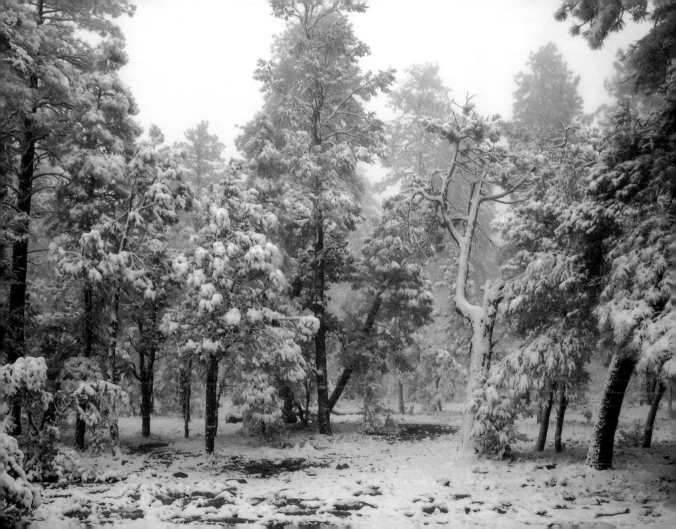

Do not care for the names of things
or for the particulars.
It is the patterns that call out to you.
For in patterns you find the hand of God –
in names, the hand of man.
All you possess are words.
What you are is a play of light
upon the still hand of eternity.

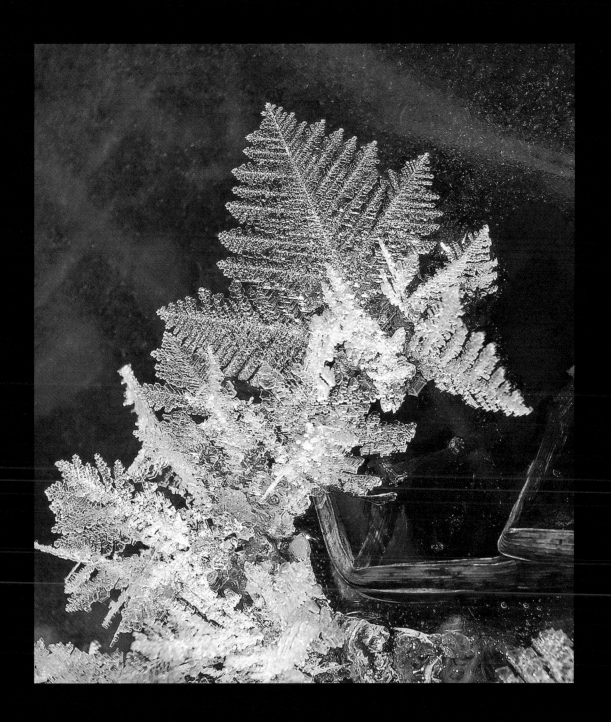

I've been here forever
and in another place as well,
that holds eternity
as I hold snow in my hand –
melting me over and over.

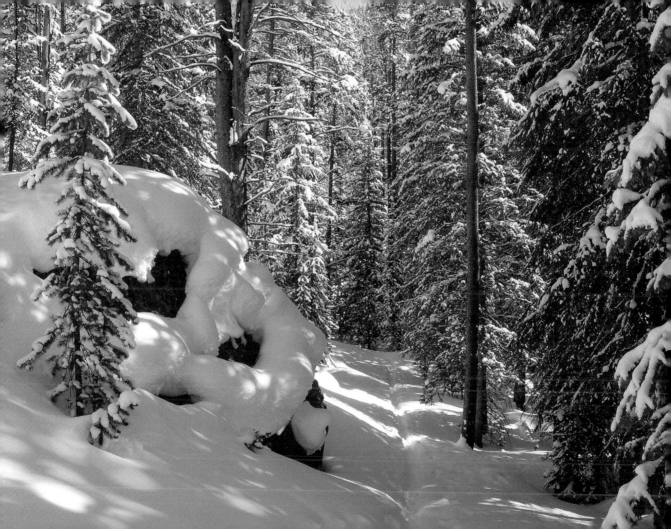

I look right through
into Shining,
and will never capture those eyes with these.

My heart was out there all along.

This world just gives images
that give words
to Shining.

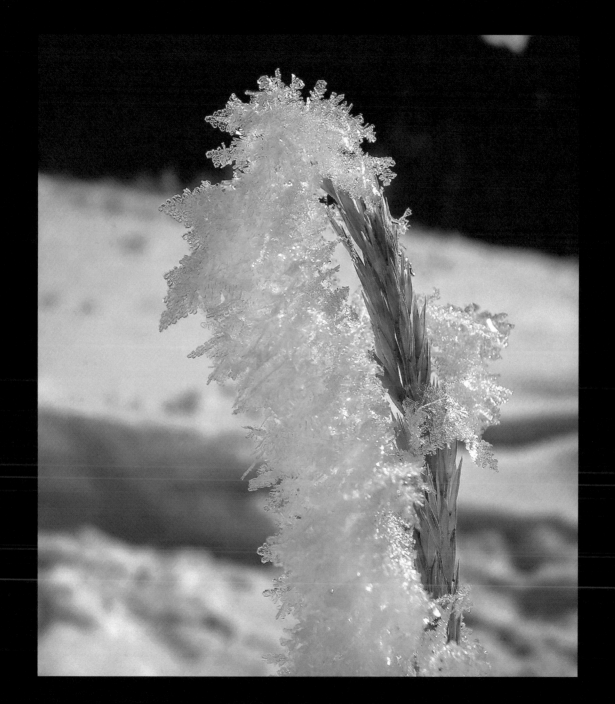

I exist on the border
between this place and none.
One foot in the world
of loneliness and love
and the other foot doesn't exist.
I might fall within any moment
– what with this unpredictable wind –
certain only that
this can't be wrong.

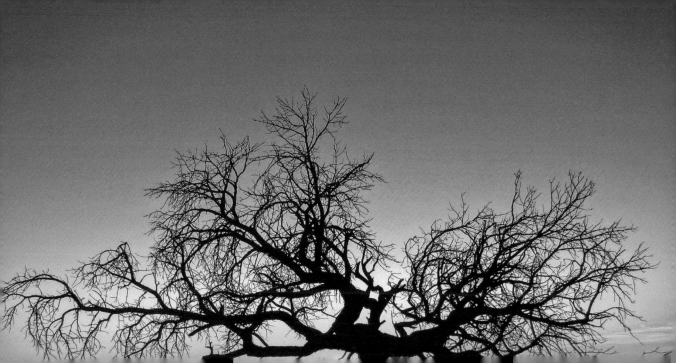

We are a curtain,
sheer and pale,
over an open window.
Wind and Light pour through
even as we believe
we hold back the night.

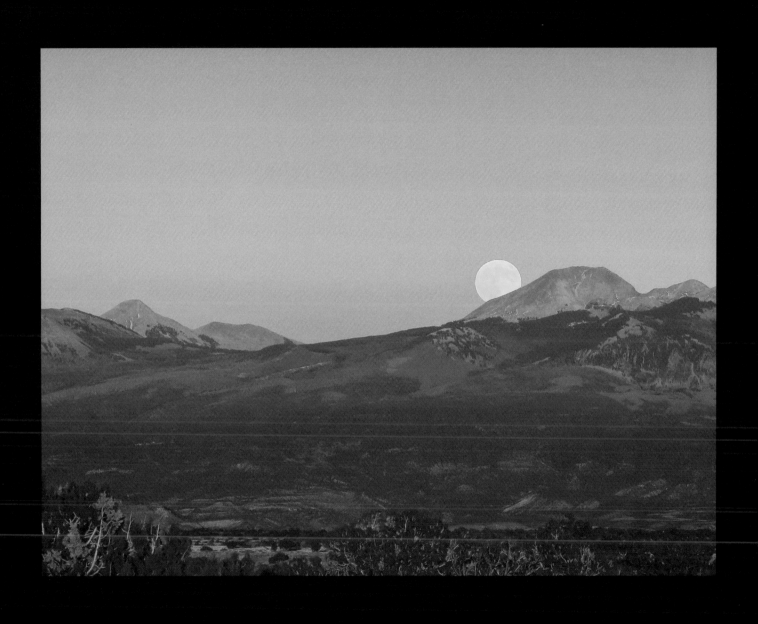

This is surely the last warm day;
a steady wind like this always brings change.
You are soaking up the sun
as if it weren't already too late.
You can't stop this change.
All the suns in the universe
aren't enough to hold back the night
in which you rest.

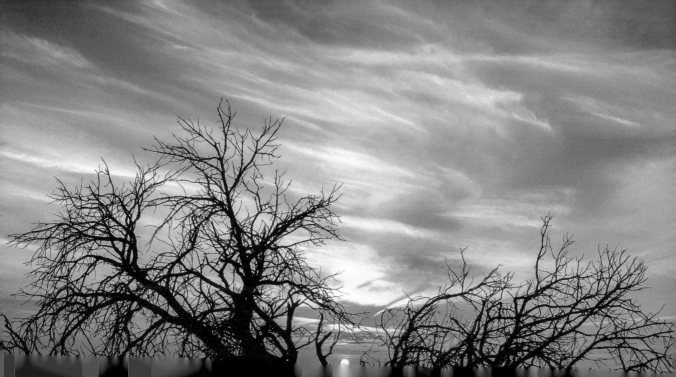

Where is within?
Where is this place of answers?
All I thought was within is without.
All I held dear, I did not hold at all.

The sun shines on my memories
tinted with the reflection of love.
Reflections deflecting my question.

Looking, asking, wanting, this haunting
twilight, not my sunlight,
unveils within:
emptiness, vastness, space.

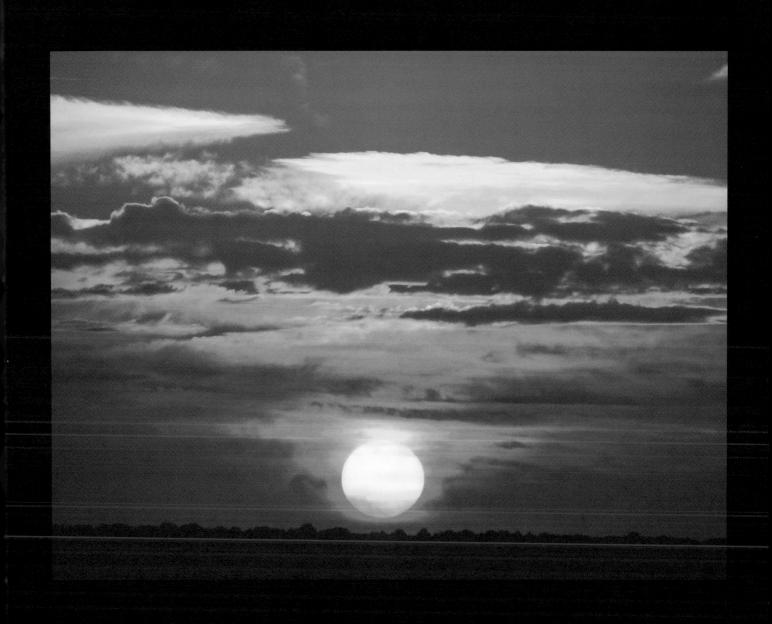

Shawn Nevins is a poet and filmmaker based in California. He was born and raised in Kentucky. After leaving the area for graduate school in North Carolina, he spent the next decade in a spiritual search that led him from a Zen master in the wilds of West Virginia, to an iconoclastic Christian mystic in the heart of Los Angeles, and an architect-turned-sage in Nacton, England. His poetry is an attempt to share what he discovered in that search.

Poems by Shawn have appeared in *Lilliput Review, Sacred Journey* and *Poetry Chaikhana.* See more of Shawn's work, including the documentaries *Closer Than Close* and *Traveling Lighter,* at *poetryinmotionfilms.com.*

Bob Fergeson is a Colorado-based photographer, kayaker, and mountaineer. Bob grew up in in a small town in southeastern Louisiana, and attended LSU before moving to Colorado. His search for something meaningful in life led him to Boulder where he studied dream work and the men's movement. Eventually it took him to West Virginia and the Zen teaching of Richard Rose. His current obsession is to capture glimpses of essence through photography.

Bob's photographs have been featured in *The TAT Forum,* and his website, *nostalgiawest.com.* He lives in Colorado, roaming the countryside in search of photographic gold while working in the tourist/service industry.

Images of Essence is also available in a premium, hardbound version which makes a wonderful gift. Visit NostalgiaWest.com to learn more.

Other Books from TAT Foundation Press

Beyond Mind, Beyond Death—An anthology of the best essays, poems, and humor from the TAT Forum online magazine.

The Perennial Way by BART MARSHALL—New English versions of Yoga Sutras, Dhammapada, Heart Sutra, Ashtavakra Gita, Faith Mind Sutra, and Tao Te Ching.

The Listening Attention by BOB FERGESON—How can we re-connect, open the Gateway to Within, and once more gain the Peace and Understanding of our Inner Self?

Solid Ground of Being by ART TICKNOR—An extraordinary spiritual journey, which hopes "to inspire another with a possibly unimagined possibility, and to encourage another to persevere."

Beyond Relativity by ART TICKNOR—From human failings to transcendent revelations, this is an insider's view of what it means to be a modern spiritual seeker.

A Handyman's Common Sense Guide to Spiritual Seeking by DAVID WEIMER—Alternating between practical advice and heartfelt exhortations, Weimer inspires readers to pursue their own understanding of existence.

At Home with the Inner Self by JIM BURNS—The only living person that Richard Rose spoke of as having "made the trip."

The Celibate Seeker by SHAWN NEVINS—A survey of people's experiences with celibacy as a spiritual practice, offering a wealth of practical advice and insight.

CPSIA information can be obtained at www.ICGtesting.com
Printed in the USA
BVIW12n0229211018
530442BV00069B/173